RENOIR'S WOMEN

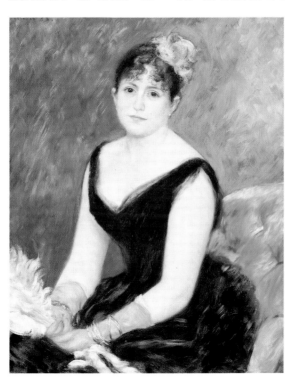

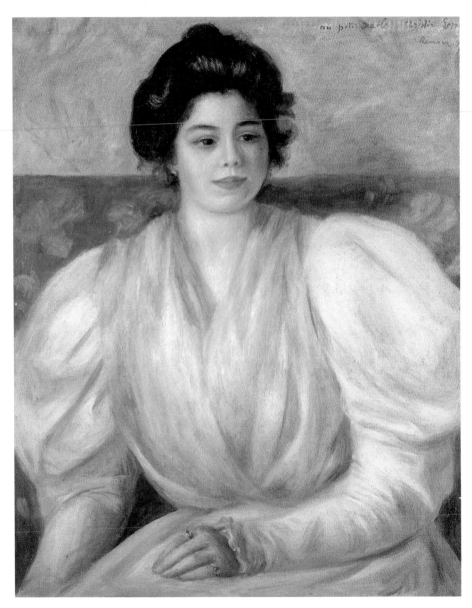

PORTRAIT OF CHRISTINE LEROLLE, 1897

RENOIR'S WOMEN

TIGER BOOKS INTERNATIONAL

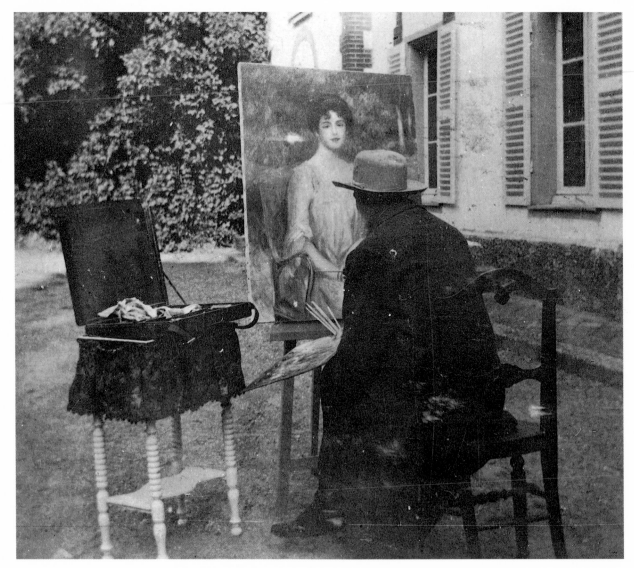

RENOIR PAINTING AT FONTAINEBLEAU, 1901

INTRODUCTION

Pierre-Auguste Renoir (1841–1919) was perhaps the most complex of the Impressionist painters, at once radically modern and a reactionary with a love for traditional art. Jean Renoir's book, *Renoir: My Father*, published in 1958, provides us with an unusually detailed insight into the painter's life and feelings. Although he states at the beginning of the book that every historical account is subjective and therefore has its own inaccuracies, the stories told leave the reader feeling as if the artist's true personality has been exposed. There are many other records of Renoir's often outrageous comments about life and art, including the dealer Ambrose Vollard's book of personal recollections, and it seems that the artist was always ready to express his point of view, however controversial this might have been. From these accounts we are left with a suspicion that the artist enjoyed making contrary statements and often said things in order to be provocative – particularly on the subject of women. It is therefore essential to consider his remarks with close reference to his paintings, for the man was essentially an artist, who communicated through visual language.

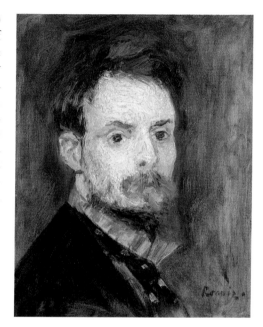

RENOIR'S *SELF-PORTRAIT*, C.1875

Renoir's most dominant theme, to which he returns throughout his career, was that of feminine beauty. He did not paint women either as classical beauties seen in the light of academic rules of idealization, or as they might appear in everyday life; rather he portrays friends, family and patrons in accordance with his own vision of what women should be – an element of 'nature seen through a temperament'. Even in his most classical of paintings, the *Bathers* of 1884, the water nymphs have their hair arranged in nineteenth-century styles, while his portraits of contemporary women show the sitters as rather passive objects to be admired by artist and viewer alike.

For Renoir, who began his career as a decorator of porcelain, the essential function of art was the representation of beauty, so that our lives could be made more pleasant and enjoyable through the contemplation of objects and images. For this reason he sits somewhat uneasily within the so-called Impressionist group. Whereas contemporaries such as Claude Monet, Camille Pissarro and Edgar Degas were attempting to develop a technique

and range of subject matter which would represent the reality of the world around them and their experience of it, Renoir modified and later rejected this technique in order

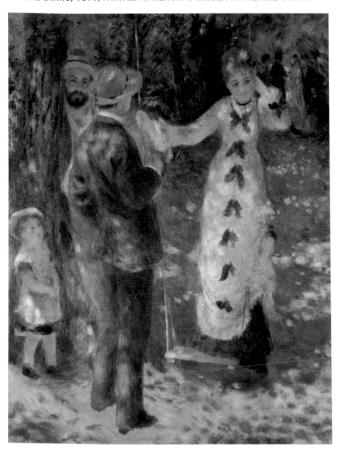

to express his own, somewhat idealized, view of reality. In a revealing statement he remarked, 'When Pissarro painted views of Paris, he always put in a funeral. I would have put in a wedding' – evidence that he was fully aware and in control of his own quite different political motivations. Pissarro was an anarchist, who took the democratic implications of Impressionism to an extreme, whereas Renoir held somewhat reactionary views about society which affected his attitude both to painting and to women.

Brought up in a working class Parisian family, Renoir had always been surrounded by traditional attitudes, which developed into a hatred and perhaps even fear of progress when combined with the breaking down of old ways of life which took place around him. In line with his belief that scientific development and mechanization could only be destructive – which he witnessed in the demise of his father's craft as a tailor and his own early

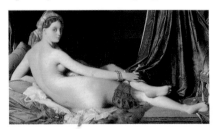

LA GRANDE ODALISQUE BY INGRES: JEAN RENOIR DESCRIBED HIS FATHER AS 'A STUBBORN DISCIPLE OF M. INGRES'

experience in the ceramics workshops which were closed down due to the invention of transfer printing – he believed that women should continue their traditional roles within society. Jean Renoir recalls his father stating, 'I like women best when they don't know how to read... Why teach women such boring occupations as law, medicine, science and journalism which men excel in, when women are so fitted for a task which men can never dream of attempting, and that is to make life bearable.'

Although there are many stories told about Renoir's affairs with various models, there was one woman with whom he spent most of his adult life. At the age of forty he was to meet and fall in love with Aline Charigot, who epitomized for Renoir the ideal woman and had the good fortune of reminding him of his mother, whom he had greatly admired. The future Madame Renoir was a dressmaker from Essoyes who now lived near him in Paris, and was only nineteen when they met. Despite the protestations of her family that an older, impoverished artist would not make a suitable husband, Aline was determined to marry Renoir and began to spend more and more time with him. There are many paintings from these idyllic days in the early 1880s for which Aline modelled, such as the *Luncheon of the Boating Party*, where she occupies the foreground. However, Jean Renoir believed that 'From the moment he took up a brush to paint, perhaps even earlier, perhaps even in his childhood dreams, thirty years before he ever knew her, Renoir was painting the portrait of Aline Charigot. The figure of Venus, on the vase which disappeared from my home during the Nazi occupation, is a materialization of my mother ten years before she was born... Naturally, Renoir did portraits of women who differed from one another physically. Yet whenever he painted subjects of his own choosing, he returned to the physical characteristics which were essentially those of his future wife.' This romanticized observation does not necessarily imply that Renoir presaged his meeting with Aline,

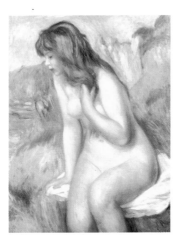

BAIGNEUSE, 1892

but that he had a clear sense of what he found attractive and was even to explain to his son the perfect proportions of a woman's face.

Despite his great love for Aline, Renoir was selective about who he introduced to her, which may reveal his insecurity where she was concerned. There were happy days spent by the Seine at Chatou with friends such as Gustave Caillebotte, but it was not until the summer of 1891, when they were married and their first son Pierre was six years old, that he introduced Aline to his circle of friends which included Berthe Morisot and Edouard Manet. Perhaps he had suspected that they saw Aline as simple and uncultured, and sought to protect her from their somewhat hostile reaction. Renoir himself always remained an outsider with the bourgeois groups of patrons and fellow artists that he met, and was insecure about, though never ashamed of his working-class background. However the Renoirs were to remain together until Aline's death in 1915, enjoying a mutual respect, perhaps because they shared views on their roles within the marriage: 'By confining her activities to what she knew best, she won the

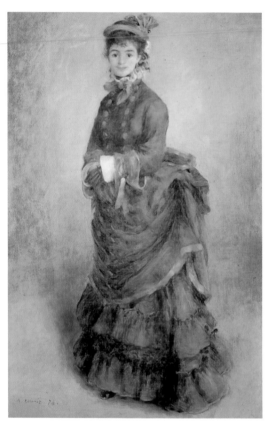

GIRL IN BLUE, 1874

admiration and respect of all who met her. Her cheerfulness and proficiency in domestic matters made her a great lady.' It is in later paintings such as *Portrait of Aline Charigot* of 1885 and *The Child at the Breast* of 1886 that we see Renoir portraying his wife in a more individual light, glorifying her as a country woman and mother, rather than as a pretty and fashionable young Parisian.

In 1928 Renoir's friend and supporter Georges Rivière wrote: 'Though he gave women a beguiling appearance in his paintings, and gave charm to those who had none, he generally took no pleasure in their conversation. With a few exceptions, he only liked women if they were susceptible to becoming his models' – which clearly contradicts the artist's claims that he felt happy only in the company of women. But it appears to have been true that Renoir felt most comfortable with women when the relationship was played out in his world, the world of painting. He became very close friends, and often lover, of the young women he selected to model for him, and usually used the same people many times once he had established a way of working with them. One anecdote

told by Jean Renoir reveals the artist's horror that one of his untitled paintings of women had been sold by Sotheby's in London under the title of *La Pensée (The Thinker)*: 'He frowned at the recollection of it. Then his eyes sparkled with malice, as he looked at his listeners. "My models don't think at all."' Like Aline, these women had looks and figures which fulfilled his idealized and rather limiting view of what was beautiful, which did not take an intellectual and enquiring mind into account.

During his training at Gleyre's studio, and in the early years as a practising artist, Renoir was strongly influenced by the artists who came to be known as the Barbizon School. Although they all had different approaches, what characterized them was their vehement opposition to the officially sanctioned, academic training and Salon system. Millet, Daubigny, Diaz and Théodore Rousseau physically removed themselves from Paris in protest and went

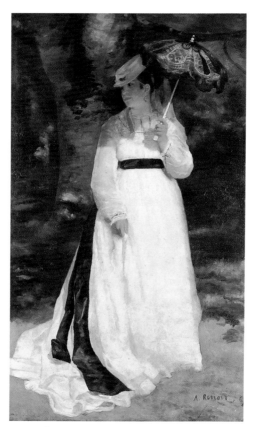

LISE TRÉHOT DEPICTED IN *LISE WITH A PARASOL*, 1867

to live and work in the Fontainebleau forest, centred around the small village from which the group derived its name. The young Renoir approved of their Realist tendencies, and developed his own Impressionist style from their approach of communicating their direct experience of

nature onto canvas. But whereas the older generation of painters had concentrated on landscape as a conveyor of contemporary reality, Renoir focused on the female figure. His model at this time was Lise Tréhot, who posed for many paintings such as *Diana* (1867), *Lise with a Parasol* (1867) and *Woman in a Garden* (1868). They became lovers until 1872 when she married the architect Georges Brière de l'Isle.

In the years before Renoir's death, when he had resolved his artistic crisis and was painting with more confidence, there were two women who played important roles in his life and art. Gabrielle Renard, the cousin of Madame Renoir who had come to live with the family in August 1894, was the dark-haired model for many of his paintings. At first, Renoir portrayed her as a member of the family group, seen with his children in *Gabrielle Playing with Jean and a Girl* (1896) or present in a family portrait such as *The Artist's Family* (1895). But later, when the family moved to the south, Gabrielle began to pose independently. This originally occurred during a holiday in Magagnosc, when all the local girls were employed for the rose gathering season or considered to be unsuitable by the artist.

Apparently it was Madame Renoir who suggested that Gabrielle might pose nude, although certain sources claim that Aline was to become jealous of their relationship and encouraged Gabrielle to marry and leave the family.

In his late seventies, and having suffered the death of his beloved wife, Renoir was being looked after by his son Jean, who had returned injured from the First World War. It was in 1918 that a young girl from Nice, Andrée Hessling, became his regular model, featuring in the late

THE HARVEST, A WATERCOLOUR SKETCH, C.1883–86

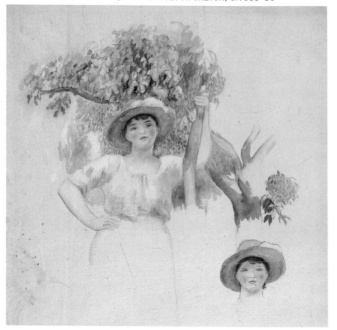

series of *Bathers* which represented the culmination of his life's work. Jean Renoir, who was later to become her husband, explains how she was a major inspiration for the artist, helping him to cope with the painful illness and declining eyesight which he suffered at the end of his life: 'She was sixteen years old, red-haired, plump, and her skin "took the light" better than any model that Renoir had ever had in his life. She sang, slightly off-key, the popular songs of the day, told stories about her girl friends, was gay, and cast over my father the revivifying spell of her joyous youth.'

Undeterred by his confinement to a wheelchair Renoir continued to celebrate the beauty of nature and his love for life, as

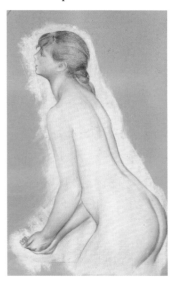

STUDY FOR THE BATHERS, C.1884–85

personified by a woman. For the artist whose sensuous brushmarks and use of colour related to his visual and physical enjoyment of the female form, the women in his paintings seem to consent to being depicted as objects to be admired. Even when meeting our gaze, they do not challenge it and appear completely at ease, suggesting that through his art Renoir created a world in harmony with his personal vision of how it should be.

THE PLATES

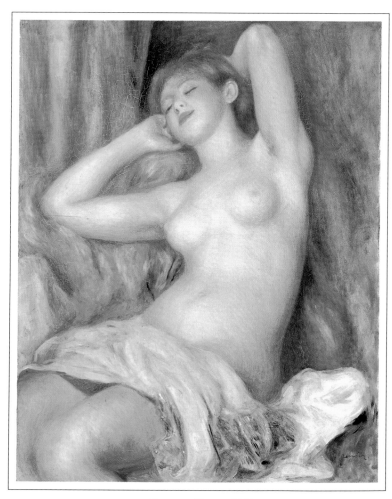

SLEEPING WOMAN, 1897

DIANA

―――1867―――

National Gallery, Washington, DC: Chester Dale Collection

'One critic, my father told me, thought he detected in the *Diana* a trace of
that "discovery of Nature" which was to make all Paris howl with rage ten
years later. He spoke of the "purity of the tones" and he even used the
expression "love of flesh". Young Renoir felt very flattered by the critic's
appraisal: "I began to think I was Courbet himself." '

Jean Renoir, *Renoir: My Father*, 1958

This passage reveals Renoir's artistic concerns at the beginning of his career
as a professional artist (or 'painter', as he preferred to be called). He
expresses his admiration for the work of Gustave Courbet while revealing
the aim which was to occupy him all his life – the search to portray what he
saw and experienced naturalistically. To a contemporary eye, this painting
appears to belong to the world of academic art, but the realistic portrayal of
the forest setting was deemed unacceptable and the picture was rejected by
the Salon of that year. Paradoxically, the nudity of the model Lise Tréhot
was sanctioned by the painting's reference to classical mythology. Despite
her fashionable hairstyle and individualized features, the figure is trans-
formed into the goddess Diana by the bow and arrow and by her
contemplation of the dramatically twisted form of her kill.

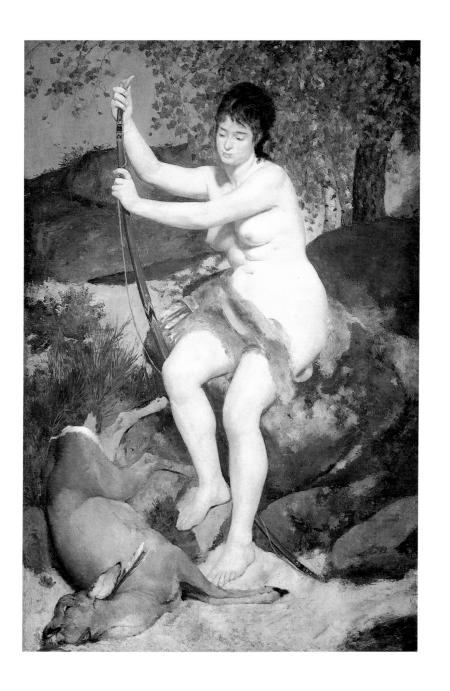

WOMAN IN A GARDEN

——— 1868 ———

Kunstmuseum, Basel

Seated in front of a backdrop of rapidly-painted and somewhat generalized greenery, the artist's friend and regular model Lise is presented as the epitome of a fashionable *parisienne*. Renoir has painted her dress by applying black shadows onto the broad expanse of deep Prussian blue, saving the careful rendering of detail for the areas where it serves to characterize the sitter who is portrayed not as a particular individual, but as a contemporary type. Using soft brushstrokes of·thin white paint against an almost solid black oval, Renoir describes the seagull feathers of her unusual hat. Similarly the gloves and gold earring are called to our attention. The side of her chair and her gaze outside the frame of the composition imply her inaccessibility to the viewer as an individual; rather she is someone for us to admire, an icon akin to the fashion plates in the popular illustrated journals of the day. The painting was formerly owned by Henri Rouart, one of the first collectors of Renoir's work.

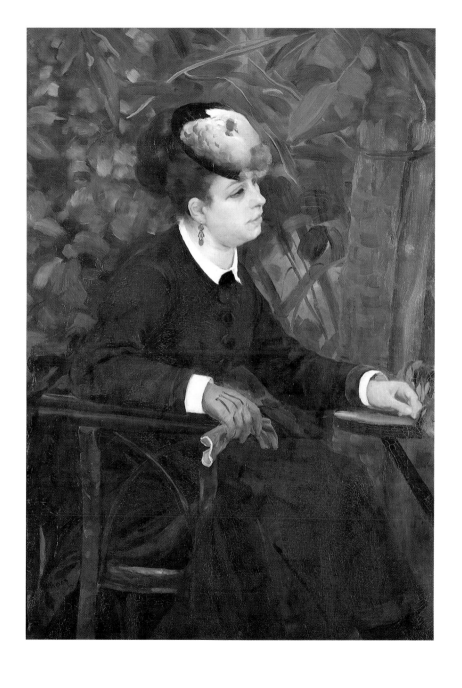

WATER NYMPH
—— 1870 ——
National Gallery, London

Effectively serving as a pendant to the *Woman of Algiers*, this painting of a water nymph is, however, quite different. The format is similar, with a reclining female figure based on the model Lise, but the image is reversed and rather than being challenged by the exotically dressed woman who intrudes on our space, here we are drawn back into the composition. The dark, mossy foliage behind the figure creates a sense of mystery and the soft, flowing lines unite the young woman with her surroundings, as she personifies an element of Nature.

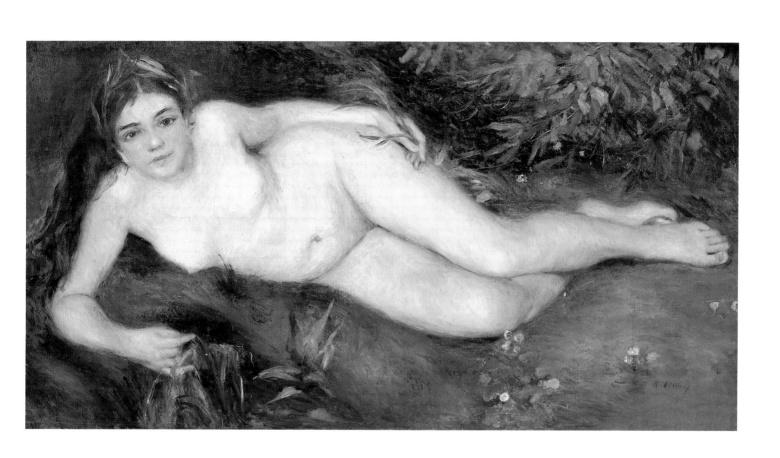

ODALISQUE / WOMAN OF ALGIERS
———— 1870 ————

National Gallery of Art, Washington, DC: Chester Dale Collection

'This painter, as we see, has a fiery temperament, which bursts upon the scene brilliantly in *The Woman of Algiers* which might have been signed by Delacroix. His master Gleyre might well be surprised at having produced such a prodigal son, who mocks every rule of grammar by daring to do things in his own way. But Gleyre is too great an artist not to recognize art whatever its forms of expression.'

Arsène Houssaye in *L'Artiste*, 1 June 1870

Such praise would have satisfied Renoir as his great admiration for the work of Delacroix must have inspired him to pose Lise Tréhot as an Algerian *odalisque*. There are many references to other works in this image: the defiance of the model's gaze is reminiscent of Manet's *Olympia* of 1865, which so shocked the public when it was first exhibited. By pushing the figure so close to the picture plane and placing a screen behind her head, we feel as if she inhabits our world, thus increasing the impact of her sexuality. Only the edge of the rug and the drapery in the background suggest the recession of space. But this painting is predominantly about the artist's delight in the rich patterns and textures of the clothes and setting. He celebrates the different effects created by the light falling onto the fabrics, for example skilfully contrasting the sleeves of the undershirt with the heavy gilded material of her trousers. Renoir was to return to the Algerian theme in later years to paint *Madame Stora in Algerian Dress*.

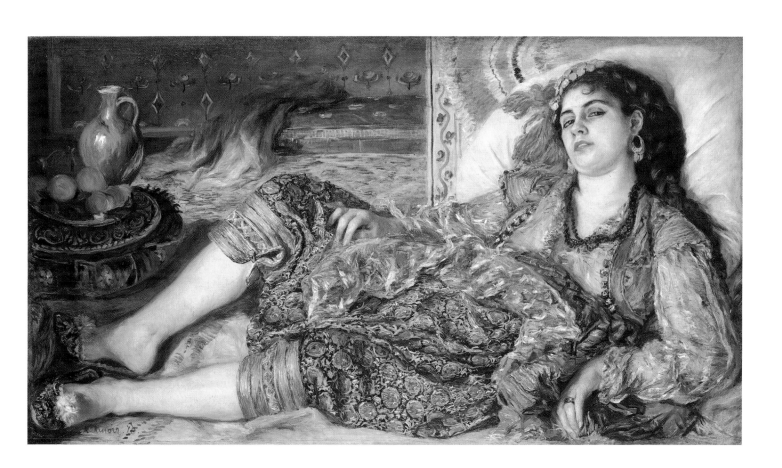

MADAME MONET AND HER SON
——— 1874 ———
National Gallery of Art, Washington, DC: Ailsa Mellon Bruce Collection

This sun-filled painting of Camille Monet and her son Jean in the garden of the Monet home at Argenteuil provides us with a wonderful record of the close relationships between the Impressionist painters in the early years of their careers. Sharing ideas about technique and subject matter, the artists often painted the same scenes, such as Monet's and Renoir's similar paintings of *La Grenouillère*. This relaxed, informal composition was commenced by Manet, with Monet shown gardening to the left, when Renoir arrived and asked to borrow a canvas and paints in order to capture the pleasant scene. Renoir's version is characterized by his soft, almost feathery brushmarks and his concentration on the central relationship of mother and child. It was supposed to have prompted Manet to whisper to their host, 'That boy has no talent. You're his friend, tell him to give up painting!'

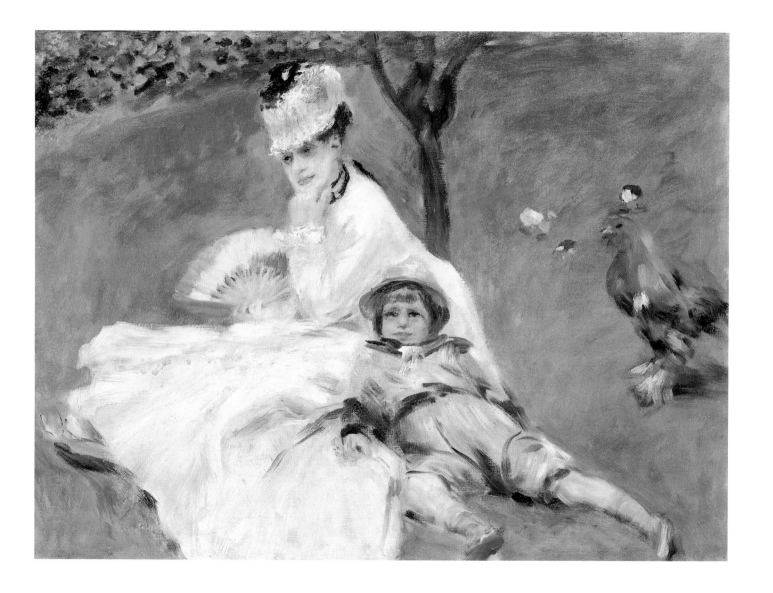

LA LOGE

1874

Courtauld Institute Galleries, London

From their richly-decorated theatre box, Renoir's brother Edmond and the model Nini pose as a bourgeois couple engaged in the popular contemporary activity of people watching. The composition cleverly involves the viewer in a game of 'see and be seen'; while the gentleman uses his opera-glasses to look at a woman in another box, we are invited to admire his finely dressed companion in the foreground. Despite the outrage expressed by many of the visitors to the first Impressionist exhibition where this painting was first shown, certain critics admired Renoir's use of colour and brushmark to build up the forms, among them Philippe Burty in *La République Française*: 'We might say that this exhibition interests us primarily for the brightness of the colour, the straightforwardness of the masses, the sheer quality of the impressions... Monsieur Renoir has a great future... his *La Loge*, particularly in full light achieves a total sense of illusion. The heavily painted and impassive figures... are fragments of painting as worthy of attention as they are of praise.' Originally sold to a dealer for 425 francs, the painting was bought by Paul Durand-Ruel in 1899 for 7,500 francs, showing how rapidly Renoir's work appreciated in value.

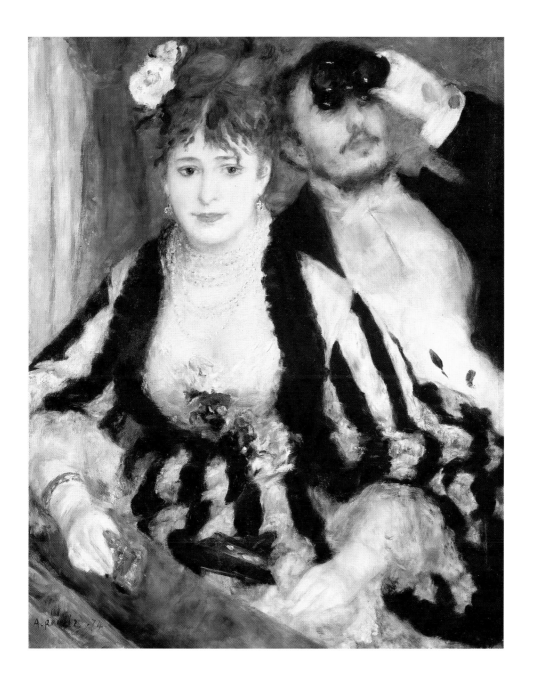

MADAME MONET LYING ON A SOFA
———— 1874 ————
Calouste Gulbenkian Foundation, Lisbon

Painted around the time of the first Impressionist exhibition, when Renoir was working very closely with Claude Monet, this painting shows his wife Camille reclining on a white sofa. Going against the tradition of portraiture, in which sitters would be arranged with carefully placed objects to make symbolic references to their status or occupation, Renoir portrays Camille as if she has been interrupted from a peaceful moment's reading. She appears relaxed, only half awake, and this dream-like quality is enhanced by the limited range of colours and application of thin paint so that the grain of the canvas shows through. The painting comes alive, however, through energetic but carefully placed flashes of colour, such as the red on Camille's lower arm which suggests movement.

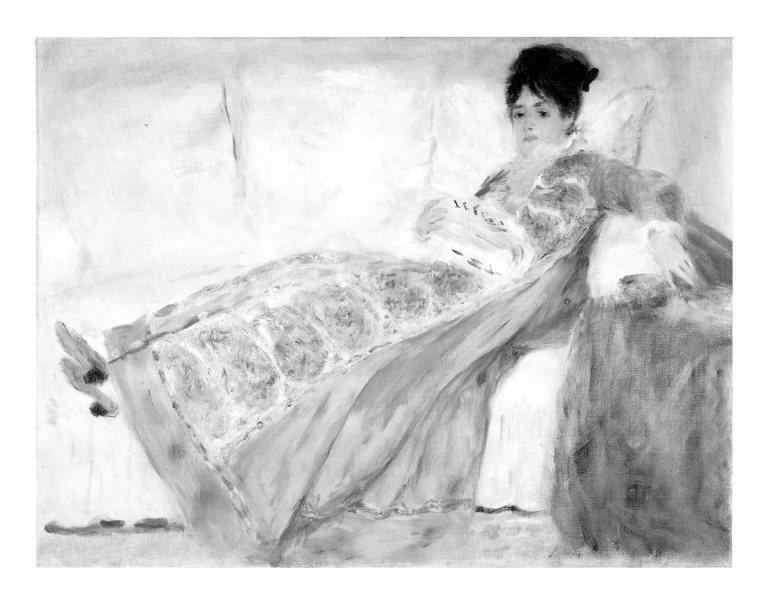

WOMAN WITH A PARASOL
———— 1874–76 ————
Museum of Fine Arts, Boston: Bequest of John T. Spaulding

It is generally believed that the subject of this painting is once again Camille Monet, but Renoir is far more concerned with the effects of light and colour than with the portrait. Painted out-of-doors, directly in front of the motif, the build-up of delicate brushstrokes captures the feeling of strong sunlight from which the woman shields herself with the parasol. In some areas the intensity of pure light is explained by patches of bright yellow paint and the dancing light bounces across the picture surface. This revolutionary technique of portraying light and atmosphere rather than specific qualities of individual objects was seen, even by contemporary critics such as Armand Silvestre, as the key contribution of the Impressionist school: 'In our view, its great merit is that it uses singularly skilful and subtle procedures to seek renewal through a direct impression of nature.'

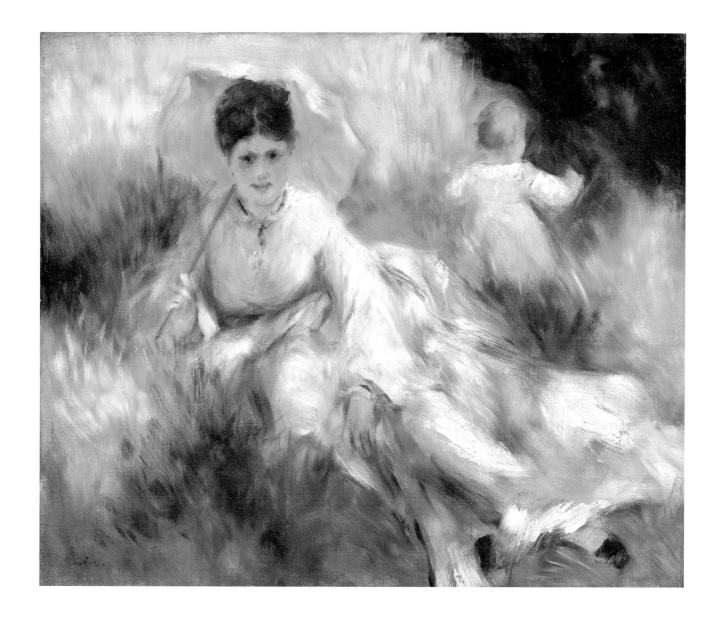

MADAME DAUDET

——— 1876 ———

Musée d'Orsay, Paris

Shown in the third group exhibition of the Impressionists, which was held at an apartment on the rue Le Peletier, this painting was one of many portraits of women submitted by Renoir. Here Madame Alphonse Daudet calmly meets our gaze, her hand delicately raised to her face. Again the sofa on which she sits and the wall behind her serve as a decorative backdrop and push the sitter forward into our space, enhancing the sense of intimacy. The success of Renoir's portraits was recognized by the critic Georges Rivière, who addressed his review of the exhibition 'To the Ladies', remarking: 'You, Madame , have been to the Impressionist exhibition, you saw there paintings full of gaiety and sunlight, and as you are young and pretty, you found the paintings to your liking, you saw portraits of women. I am too gallant to dream of implying that they are flattering, but anyway they are very pretty, and you personally would like to own a ravishing portrait which would capture the charm with which your person is blessed.'

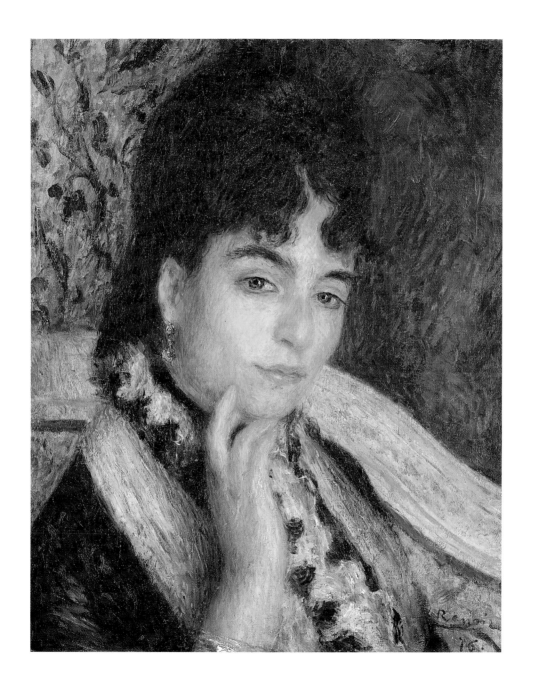

SEATED NUDE
1876
Pushkin Museum, Moscow

'He kept coming back to the picture of Nana. That lovely girl with her elegant shape and enticing flesh tempted him. But she was outrageously naked and Chabrier intended hanging the picture he bought in his drawing room. After much hesitation, and an inner struggle between his artistic sense and his bourgeois concern for what people would say, he decided to admit his preference... This large naked woman was not well received at home. It was thought to be indecent and the beautiful Nana with her lack of clothes had to leave the drawing room where she was out of place amid the respectable family portraits, and hide in a dark corner to await her definitive departure.'

Georges Rivière, *Renoir and His Friends*, 1921

Rivière's account of Emmanuel Chabrier's purchase of this picture provides us with an insight into contemporary views about the acceptability of nudity in paintings. Chabrier's comments reveal that the image was considered shocking because it shows a real, recognizable woman in an interior setting, rather than an idealized female figure representing Nature in a landscape. Presumably the shocking effect of this painting was heightened by the muted colours and beautiful silvery light which create an intimate mood, and the woman's raised arm to cover herself implying a sense of intrusion by the viewer.

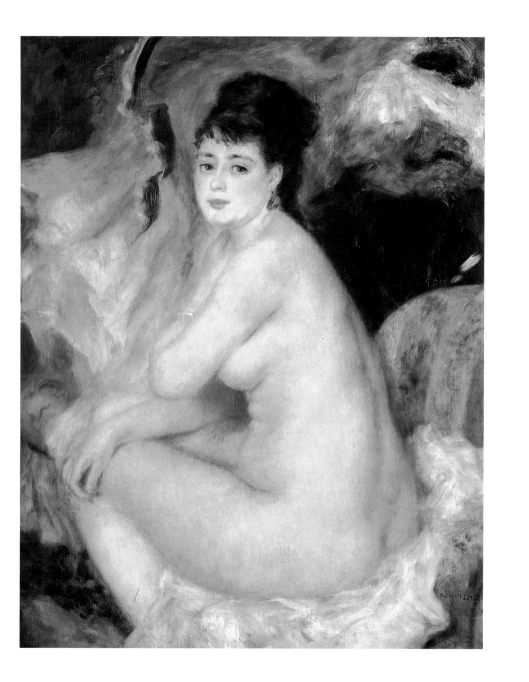

BALL AT THE MOULIN DE LA GALETTE

——— 1876 ———

Musée d'Orsay, Paris

'*Ball at the Moulin de la Galette* is one of the most successful products of direct observation and the use of light to create atmosphere: it expresses the intoxication of dancing, the noise, the sunshine and the dust of the dance in the open air, the excitement on the faces and the casual poses, the rhythmic swirl of the dresses… a burst of passion, a sudden sadness, a quick flare-up, pleasure and fatigue.'

Gustave Geffroy, *La Vie Artistique*, 1894

'Renoir is one of the prolific and daring ones in this place. I recommend… the *Bal du Moulin de la Galette* which is in no way inferior to his other work in the incoherence of its draughtsmanship, composition and colour.'

Charles-Albert Bertall in *Paris-Journal*, 9 April 1877

These two reviews show the polarity of contemporary responses to one of Renoir's most famous and ambitious paintings. In the first of his complex crowd scenes which looks back to Manet's *Music in the Tuileries Gardens* of 1862, Renoir has successfully combined a description of the general mood with more detailed figures, some of whom are recognizable as his friends, thereby conveying a true sense of the world and community of Montmartre in which he lived. Despite the somewhat sombre tones of the clothes, particularly the dark suits of the gentlemen, Renoir has captured the gaiety of the scene in the expressions and gestures of the dancers and the bright patches of light diffused by the foliage overhead.

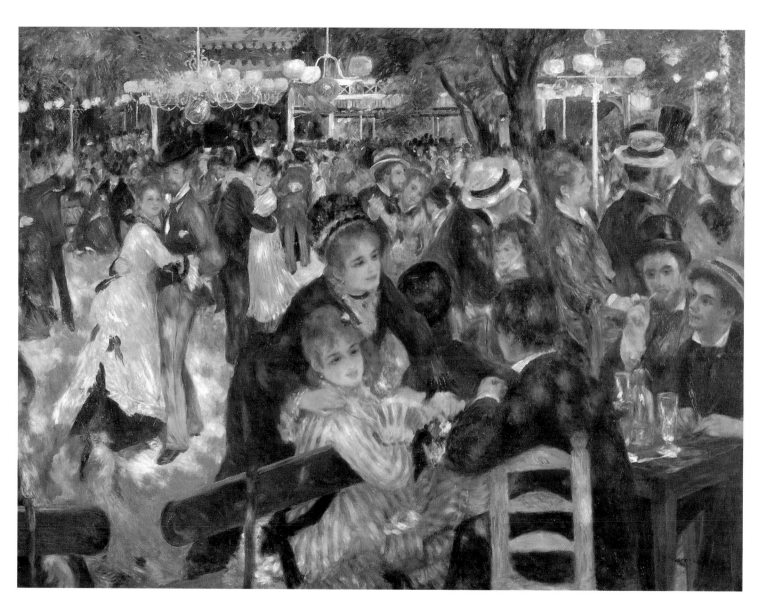

NUDE IN SUNLIGHT

——— 1876 ———

Musée d'Orsay, Paris

'Monsieur Renoir paints flesh in a thoroughly agreeable range of pink. I was enchanted by his sketch of a naked woman. It gives a taste of a true colourist.'

Armand Silvestre in *L'Opinion*, 2 April 1876

'Try to explain to Monsieur Renoir that a woman's torso is not a mass of flesh in the process of decomposition with green and violet spots, showing the state of complete putrefaction of a corpse!'

Albert Wolff in *Le Figaro*, 3 April 1876

Exhibited at the second Impressionist exhibition, this study of a nude evoked some of the most vehement criticism Renoir was to receive. Those who supported his work recognized his ability to see and portray the effects of light on the figure using complementary colours and a rhythmic series of open brushmarks. The negative responses to this new technique were aimed at all the Impressionists sharing the ideology that paintings should show 'nature seen through a temperament' as opposed to an idealized, academic vision of the past. What seemed to be most shocking and unpalatable at the time was the audacity of artists to frame and exhibit 'unfinished' sketches, rather than painstakingly finished compositions.

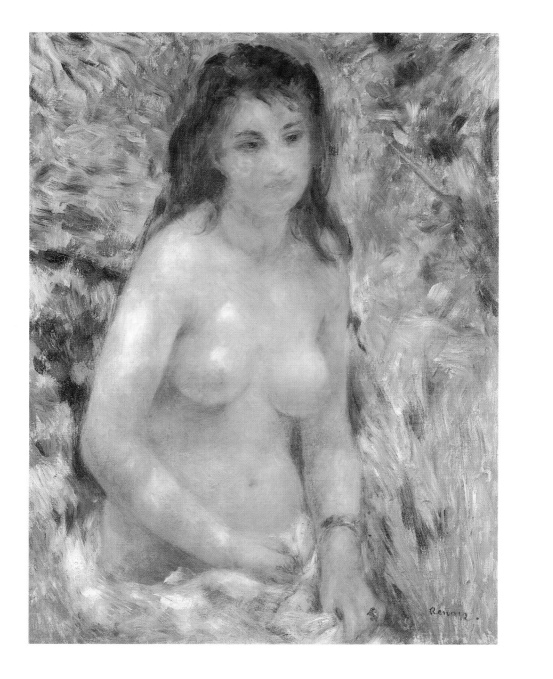

MADAME HENRIOT

———1876———

National Gallery of Art, Washington, DC: Gift of the Adele R. Levy Fund, Inc.

Unlike some of his contemporaries, Renoir had no wealthy family to give him an allowance while he struggled to make his name, and in the mid-1870s he was compelled to turn to painting portraits of society figures in order to survive. Despite the positive criticism and support of some of the more far-sighted commentators, dealers and patrons, the revolutionary style of the Impressionists was not yet seen to be acceptable. Here Madame Henriot, who had posed for *La Parisienne*, is presented as a delicate, almost ephemeral figure – qualities which the artist greatly appreciated in women. The subtle build-up of the palest pinks and blues gives the portrait a silvery light which complements the sitter who, according to Renoir, 'posed like an angel'.

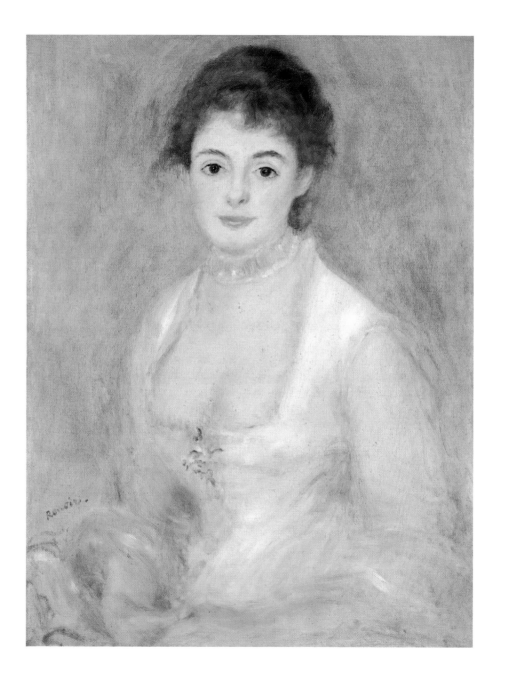

MADAME CHARPENTIER AND HER CHILDREN
———— 1878 ————

Metropolitan Museum of Art, New York: Wolfe Fund, 1907
Catharine Lorillard Wolfe Collection

Exhibited in the Salon of 1879, this painting was an important commission for Renoir and represents the beginning of his success as a well-established and highly-paid artist. Madame Charpentier was the wife of the publisher of the works of Émile Zola, Gustave Flaubert and of the Goncourt brothers, whose writing reflected the naturalist style of the Impressionists in literary form. Renoir's working-class background had ill prepared him for his entry into bourgeois circles, and although he became a frequent visitor at Madame Charpentier's famous *soirées*, he never felt entirely comfortable. This distance was a positive quality in his approach to the portrait, as it allowed him to observe the family objectively and to show the viewer not just the people but also their surroundings and way of life with accuracy and sensitivity: 'From the big Newfoundland dog in the foreground, to the amusing walls of a boudoir decorated in Japanese style, everything is ruled by a general feeling of modern harmony. The poses are of a striking aptness, and the flesh which the children offer up innocently to the kiss of light, is firm as ripening cherries,' wrote the critic Phillipe Burty. The picture was sold to the Metropolitan museum in 1907 for 92,000 francs.

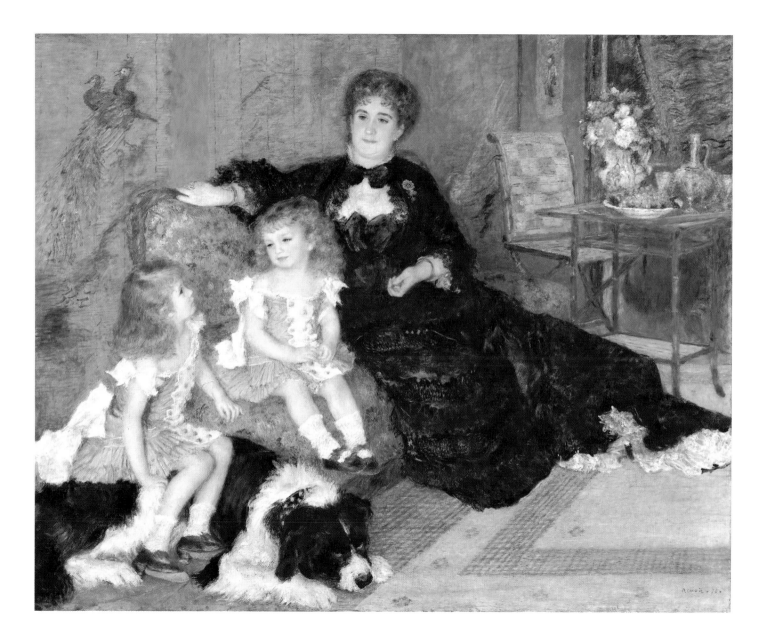

AT THE END OF THE LUNCH

—— 1879 ——

Städelsches Kunstinstitut, Frankfurt

Renoir's respect for the *genre* painters of seventeenth-century Holland, who had made everyday life the subject matter of great paintings, can be seen in pictures such as this. With his careful observation of detail, Renoir has captured the specific mood at a particular point in time, presenting us with the precise moment of relaxation at the end of a sociable meal. The seated woman sips a *digestif* and the man lights his cigarette; both are universal gestures as well as specific incidents. Once again Renoir shows his preference for painting female figures by placing the man on the far right, almost cropping him out of the picture, while the two women regard him with open, full faces unobscured by any objects. The use of black and white, which is reversed in the figures of the two women in a play of positive and negative, is complemented by the patches of colour in the background and is in turn picked up by the box of matches on the table.

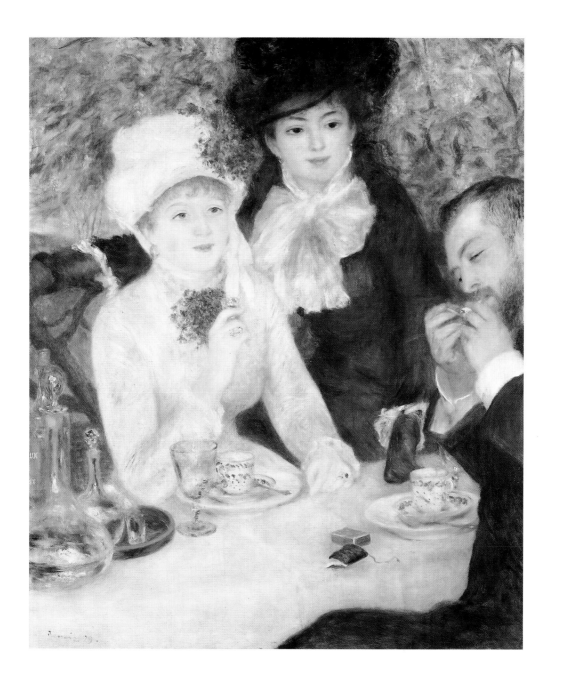

THE FIRST OUTING
—————1880—————
National Gallery, London

Similar in theme to *La Loge*, with the key focus being a box at the theatre or *Opéra*, we witness in this painting the excitement and trepidation of the young woman's first evening out. Rather than encountering the model's confident gaze, as in the earlier picture, we sit just behind her, perhaps as chaperone or mother and share her experience, although, unlike her, we are aware of the enquiring gaze of the woman in the distant box. The golden curve of the wall of the box separates the intimate world of the individual figure from the crowd below, supported by the contrast in style where the figures below are painted more rapidly and with less detail to give a sense of movement. Renoir portrays the mixed emotions and nervous excitement of such an experience with delicacy and sensitivity.

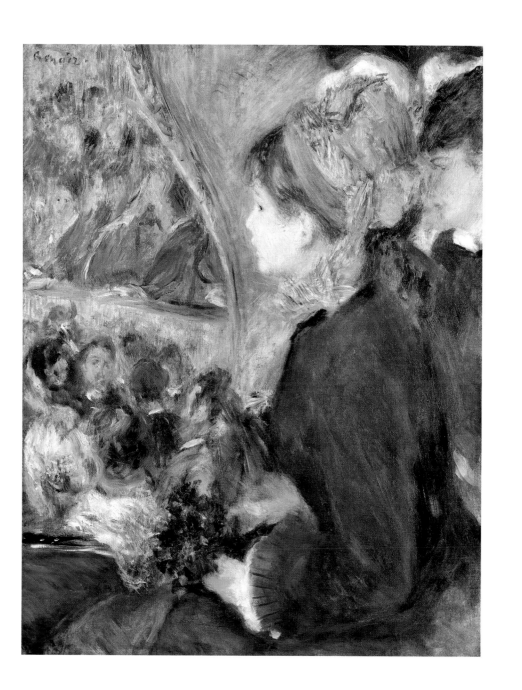

LUNCHEON OF THE BOATING PARTY

—1881—

The Phillips Collection, Washington, DC

'Renoir is unique among this essentially liberal group. His *Déjeuner à Bougival* seems to me one of the best things he has painted… There are bits of drawing that are quite remarkable, drawing – true drawing – that is a result of the juxtaposition of hues and not of line. It is one of the most beautiful pieces that this insurrectionist art by Independent artists has produced. I find it absolutely superb.'

Armand Silvestre in *La Vie Moderne*, 11 March 1882

This lively and informal scene met Émile Zola's challenge to the Impressionists to paint more complex compositions, and shows Renoir's ability to balance figures, objects and setting successfully. The lunch party takes place under the striped awning of the terrace restaurant at Chatou owned by the Fournaise family, with whom Renoir was great friends. In the hazy blue distance, spanning the river, we can just make out the railway bridge which made the riverside resort accessible to the many day-trippers wanting to escape Paris. Painted on an unprimed canvas with flickering highlights of thick, white paint, the scene suggests a mood of relaxation and pleasure. Despite the presence of recognizable male figures, such as the painters Caillebotte and Lestringuez, it is the women, with their faces turned towards us, who receive our attention and it is Aline Charigot, who was to become the artist's wife, who leads our eye into the painting.

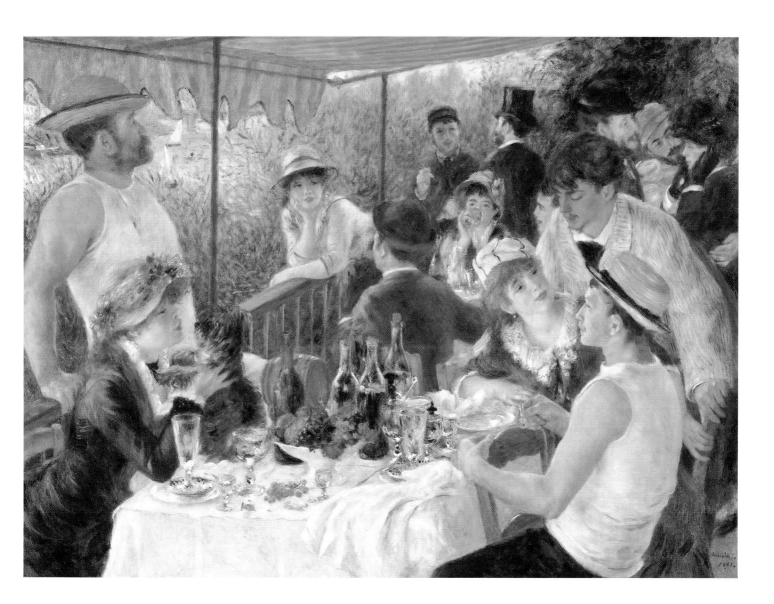

SISTERS / ON THE TERRACE
———— 1881 ————

Art Institute of Chicago: Mr and Mrs Lewis Larnad Coburn Memorial Collection

'His nudes and his roses declared to the men of this century, already deep
in their task of destruction, the stability of the eternal balance of nature.'

Jean Renoir, *Renoir: My Father*, 1958

Although Jean Renoir made this observation with reference to paintings
made by the artist in the last few years of his life, we can see how strong the
theme was throughout his career. Always horrified by war and the destruc-
tion of traditional ways of life through industrialization, Renoir returned to
the universal theme of natural beauty in his work, often presenting us with
an unrealistic vision of the world in accordance with his own preferences
and values. Here the mother and child, with their brightly coloured hats
and flowers, are completely surrounded by nature; even the 'man-made'
terrace on which they sit is encroached upon by climbing plants. Renoir
makes a visual comparison between the purity and beauty of the figures
and the calm landscape seen behind them, where only the gliding skiffs of
holiday-makers disturb the water.

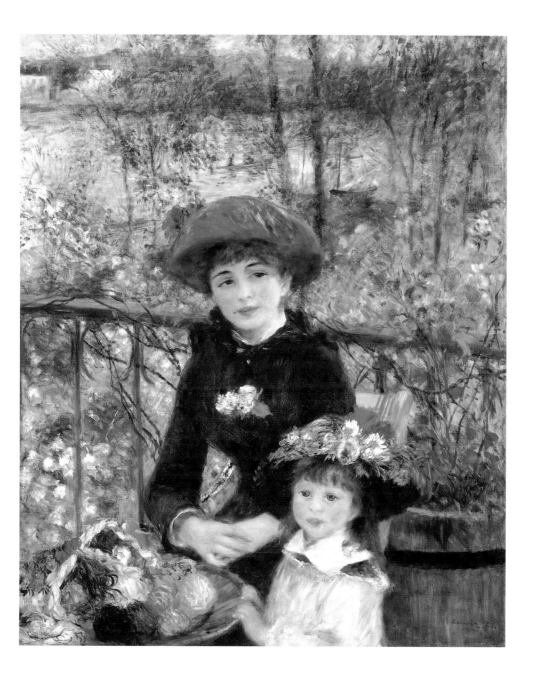

UMBRELLAS
c.1881–85

National Gallery, London

'He remained as simple a man as when he started out, unsusceptible to vanity or flattery, unconcerned about honours... There was an occasion, however when he was visibly moved by a tribute. It was in July 1917. One of his paintings was exhibited at the National Gallery on its way to an Irish museum. He was sent a letter signed by one hundred or so English artists and collectors which said: "From the moment your painting was hung amid the masterpieces of the past, we had the pleasure of observing that one of our contemporaries has immediately taken his rightful place among the great masters of the European tradition."'

Albert André, *Renoir*, 1919

It is interesting that one of Renoir's most problematic paintings was to be the source of such great honour and praise. Marking the transition in his work between Impressionism and a more classical style, the picture is divided diagonally into two almost separate sections which are easily dated with reference to the fashions of the dresses. On the right the group of women and children are painted in loose patches of light and colour, while the couple on the left are portrayed using a more linear and defined style. Despite the unifying composition, aided by the basket which bridges the two sections, there is a strange dislocation of time in this painting which marks an important development in Renoir's work.

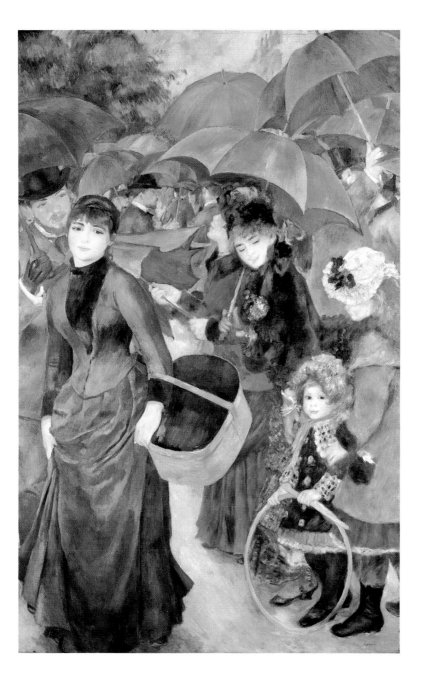

MADAME HÉRIOT

—1882—

Kunsthalle, Hamburg

'He is truly a painter of women, alternatively gracious and moved, knowing and simple and always elegant, with an exquisite visual sensibility, a touch as light as a kiss, a vision as penetrating as that of Stendhal. Not only does he give a marvellous sense of the physique, the delicate tones of young complexions, he also gives a sense of the *form of the soul*, all woman's inward musicality and bewitching mystery. Contrary to the majority of modern painters, his figures are not frozen over by layers of paint; animated and vivacious, they sing out the whole range of bright tones, all the melodies of colour, all the vibrations of light.'

<div align="right">Octave Mirbeau in La France, 8 December 1884</div>

Mirbeau's poetic support for Renoir's portraiture describes not only this picture but also many like it. We are presented with a calm, confident woman whose sense of fashion and taste is shown through the decorative oriental robe she wears over her dress. This also serves as a pictorial device, for by contrasting the deep reds of the surroundings with the paler tones of Madame Hériot's face and clothing the artist successfully describes the sitter, not just in terms of her physical appearance, but also her personality.

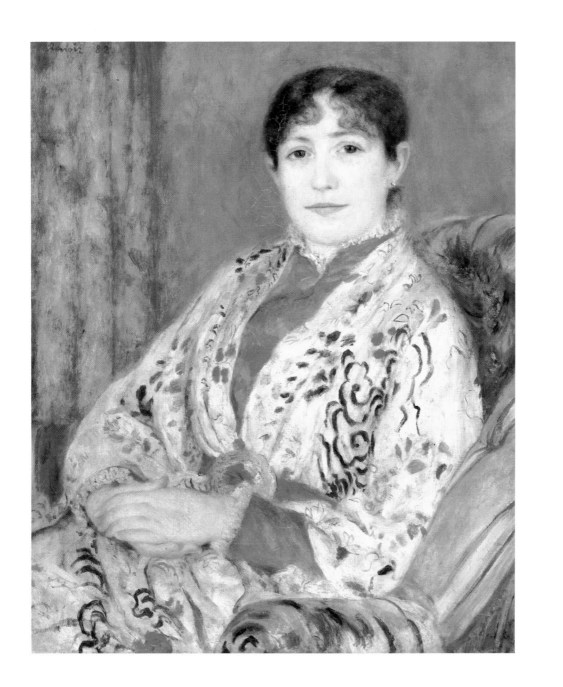

DANCE AT BOUGIVAL
——— 1882 ———
Museum of Fine Arts, Boston

DANCE IN THE CITY
——— 1882 ———
Musée d'Orsay, Paris

These two panels were painted (with a third showing life-sized dancing couples) over the winter of 1882–83. They are often given different titles, for example *Summer* and *Winter*, but it is clear from his statements that Renoir intended them to be seen as what they are, without any symbolic references or implied narrative. However, when we look at the panels in combination we can see that they explain the different moods and codes of social behaviour experienced in the city and countryside at the time. Marie-Clementine 'Suzanne' Valadon, who was also a painter, modelled for these two images and her partner is the writer Paul Lhote, who used the *Dance at Bougival* to illustrate his story *Mademoiselle Zélia* when it was published in *La Vie Moderne* in 1883. But the couple look quite different in the two paintings: in the former they dance in an open and relaxed manner, her dress flaring out as she swings around, but in the latter the dance is more formal and contrived. This change in atmosphere is further expressed through the use of colour and the contrast between the backgrounds; where one couple dance amongst a crowd of people and trees in the open air, the other is isolated in a somewhat cold environment before a screen of potted palms.

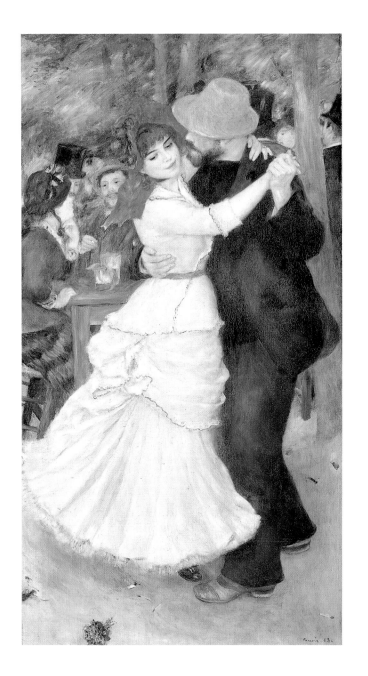
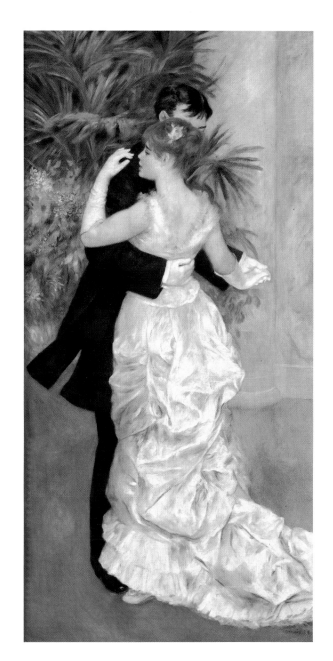

SEATED BATHER

——1883——

Harvard University Art Museum: Bequest of Maurice Wertheim

Returning once again to the classical theme of the female nude in a landscape setting, Renoir appears to be celebrating the relationship between the figure and her surroundings. The bright, pure colours and expressive brushmarks with which he describes the rocks and water create a decorative backdrop for the more solid figure, making us aware of the play of the two-dimensional reality of the canvas and the illusion of three-dimensional space. Studies for this painting were made during a two-month visit to the island of Guernsey, from where he wrote to his friend and dealer Paul Durand-Ruel: 'I've found myself a charming beach here which is quite unlike our Normandy beaches... They bathe among the rocks, which serve as cabins since there is nothing else. This mixture of men and women is charming. It feels more like being in a Watteau landscape than in the real world.'

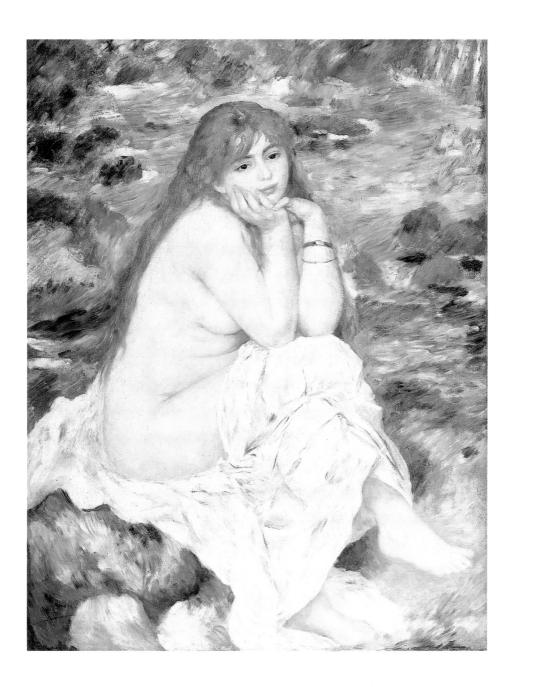

THE BATHERS
―――― 1884 ――――
Philadelphia Museum of Art: Mr and Mrs Carroll S. Tyson Collection

'For several years Renoir experienced unease, and sometimes despair, as he studied the old masters, whose fervent and fearful admirer he remained. He was looking for a more solid, a more classical art, self-sufficient, beyond the sensual charm he was so adept at adding to it. *The Bathers* which he exhibited at the rue Sèze in 1887 will continue to bear witness to these years of quest and hesitation. I cannot forget the quite unearthly emotion aroused in me by this gentle but strong painting, this delicious mingling of looking and dreaming.'

Téodor de Wyzewa, *Painters of Today and Yesterday*, 1903

This writer, who was a close friend of Renoir's and a critic for the *Revue des Deux Mondes*, clearly expresses the crisis which the artist suffered in the early 1880s. Having re-examined the painters of the Italian Renaissance tradition, he developed a new style epitomized in this painting, where the figures refer to classical sculpture and are clearly delineated against the backdrop of water and trees. Using a smoother, flatter brushmark, Renoir builds up the volume of the forms using subtle shades of light and dark, and dapples the surface with an idealized golden light. The final composition was derived from numerous preparatory drawings, some based on François Giradon's relief sculptures at Versailles, showing how different this painting is from his more spontaneous earlier works, painted *en pleine-air*.

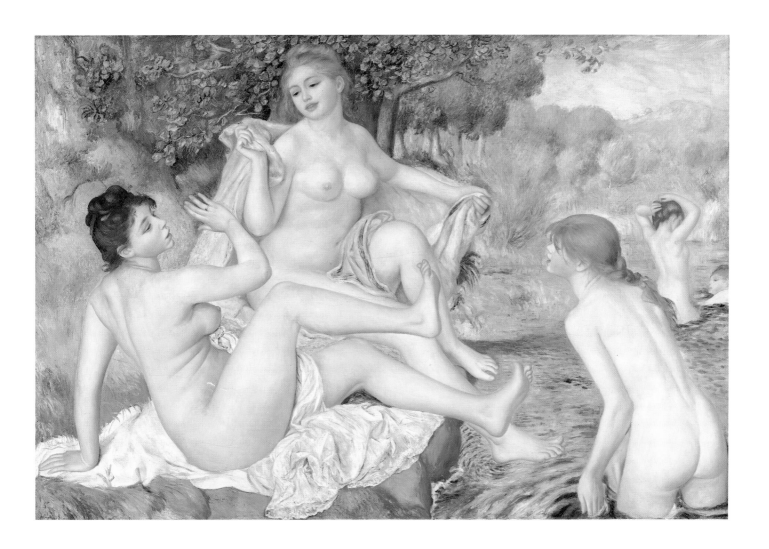

GABRIELLE WITH ROSE
―――1910―――
Skira Collection, Geneva

In his book, *Renoir: My Father*, Jean Renoir gives an account of the arrival of Gabrielle Renard in the household at the Château des Bruillards in Montmartre, and affectionately recalls her presence in the family: 'She was only fifteen at the time. She was a cousin of my mother's, and had come from Essoyes a few months before to help with the preparations for my birth. Years afterwards, when she and I played the little game of taking a trip into the past, she told me again that I had been a magnificent baby, and added, "Too bad you changed!"' In this picture, painted sixteen years later, Gabrielle is presented as sensual and exotic, adorning herself with flowers and jewellery, rather than the practical and earthy woman Jean describes. The warm gold and red hues and the feathery brushstrokes reflect Renoir's ideals of feminine sensuality, where the woman displays herself to the painter and viewer, as well as enjoying her own beauty in the mirror.

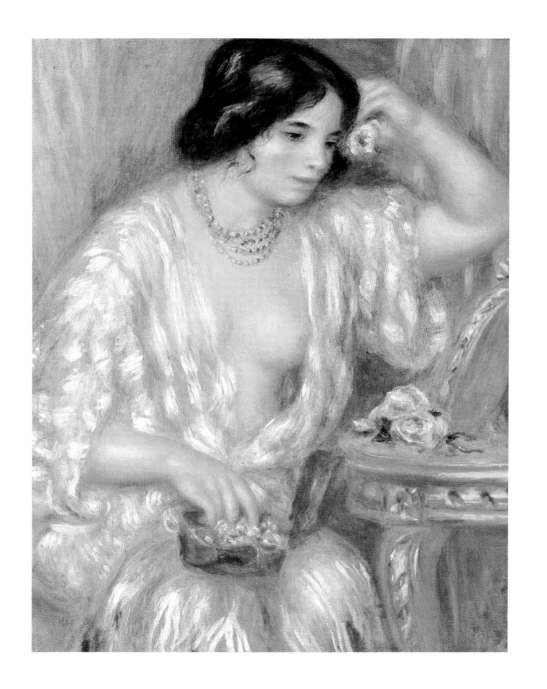

THE BATHERS
———— 1918 ————
Musée d'Orsay, Paris

Painted the year before his death, this sees Renoir returning to his favourite theme: the celebration of female beauty in a landscape setting. Identical in format and size to the 1880 *Bathers,* this version appears to dissolve the subject matter into a mass of colour and marks. The figures are no longer separate from the landscape but harmonize with the surrounding trees and water by sharing the tones and highlights. Determined to create a final testament to his life's work, but crippled by arthritis, Renoir painted this from his wheelchair with his paintbrush strapped to his hand. Helped by his son Jean and their maid 'Grand' Louise', he would work from the shelter of a glass-sided studio amongst the olive trees in the garden at Les Collettes, adjusting the large canvas on a specially designed easel. The red-headed model who posed for the lower figure was Andrée 'Dedée' Hessling, the future wife of Jean Renoir, who he describes as 'one of the vital elements which helped Renoir to interpret on his canvas the tremendous cry of love he uttered at the end of his life.'

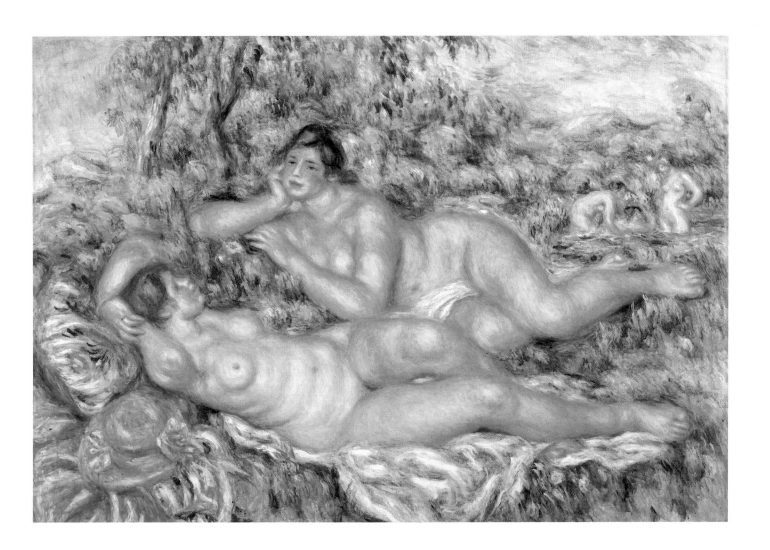

THE CONCERT

—1919—

Art Gallery of Ontario, Toronto: Gift of Reuben Wells Leonard Estate, 1954

Any sense of three-dimensional space has dissolved in this network of golden curves and glittering highlights. The painting is again a celebration of feminine sensuality, with everything richly decorated and pleasing to the male eye. The structure is predominantly two-dimensional and decorative, the strong vertical elements of the seated figure, curtain folds and table legs are broken into and contrasted by the curving forms and sinuous lines. Again we see Renoir comparing the beauty of a woman to that of a rose – a motif that recurs throughout the composition – something to be cultivated and admired. This picture, on which the artist was working when he died, shows the wonderful skill with which he could still control a painting, an ability he himself referred to in what were reportedly his final words: 'At last, I begin to show promise!'

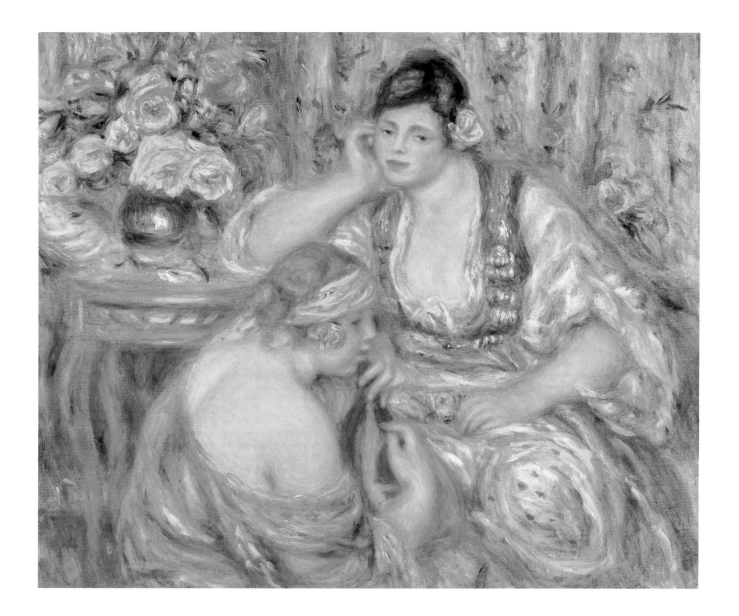

First published in Great Britain in 1994 by
PAVILION BOOKS LIMITED
London House, Great Eastern Wharf, Parkgate Road
London SW11 4NQ

This edition published in 1998 by
Tiger Books International PLC, Twickenham, U.K.

Conceived, edited and designed by Russell Ash & Bernard Higton
Picture research by Mary-Jane Gibson

A CIP catalogue record for this book is available from
the British Library

ISBN 1 85501 984 1

2 4 6 8 10 9 7 5 3 1

Printed in China by Sun Fung Offset Binding Co.
Produced in association with The Hanway Press Ltd., London

Picture credits
All plates are from the sources shown in captions unless otherwise
indicated below.

Front cover (detail) as plate page 41; page 1 (*Portrait of Madame
Clapisson,* 1883) The Art Institute of Chicago: Mr and Mrs Martin A.
Ryerson Collection; 2 private collection; 4 Sirot Collection, Paris;
5 Sterling and Francine Clark Art Institute; 6 left Musée d'Orsay,
Paris, right Musée du Louvre, Paris; 7 left private collection,
right Durand-Ruel, Paris; 8 National Museum of Wales, Cardiff;
9 Folkwang Museum, Essen; 10 left Musée du Louvre, Paris, right
Art Institute of Chicago: Bequest of Kate L. Brewster; 11 Oskar
Reinhart Collection, Am Römerholz, Winterthur; back cover
detail as plate page 59.

Photo sources: Artothek; Bridgeman Art Library;
Giraudon; Colorphoto Hans Hinz; Photo RMN; Scala;
Weidenfeld & Nicolson.